"Everything
is design.
Everything!"

"It is important to use your hands, this is what distinguishes you from a cow or a computer operator."

"Design is also a system of proportions, which means the relationship of sizes."

# Paul Rand

Conversations with Students

Conversations with Students
A Princeton Architectural Press series

Santiago Calatrava
978-1-56898-325-7

Le Corbusier
978-1-56898-196-3

Louis I. Kahn
978-1-56898-149-9

Rem Koolhaas
978-1-885232-02-1

Ian McHarg
978-1-56898-620-3

Peter Smithson
978-1-56898-461-2

# Paul Rand

**Conversations with Students**

Michael Kroeger

Foreword by Wolfgang Weingart

Texts by

Philip Burton

Steff Geissbuhler

Jessica Helfand

Armin Hofmann

Gordon Salchow

Princeton Architectural Press, New York

Published by

Princeton Architectural Press

37 East Seventh Street

New York, New York 10003

For a free catalog of books, call 1.800.722.6657.

Visit our website at www.papress.com.

Every reasonable attempt has been made to
identify owners of copyright. Errors or omissions
will be corrected in subsequent editions.

All books referenced in the text are given full
citations in the bibliography.

The foreword by Wolfgang Weingart is
reproduced by permission of the publisher from
Franc Nunoo-Quarcoo, *Paul Rand Modernist
Design* (Baltimore: Center for Art and Visual
Culture, University of Maryland, Baltimore
County, 2003).

The interview text presented in this book was
originally published on the author's website,
http://www.mkgraphic.com.

Editing: Linda Lee

Design: Deb Wood

Special thanks to:

| | |
|---|---|
| Nettie Aljian | Jan Haux |
| Sara Bader | Clare Jacobson |
| Dorothy Ball | John King |
| Nicola Bednarek | Nancy Eklund Later |
| Janet Behning | Laurie Manfra |
| Kristin Carlson | Katharine Myers |
| Becca Casbon | Lauren Nelson Packard |
| Penny (Yuen Pik) Chu | Jennifer Thompson |
| Russell Fernandez | Arnoud Verhaeghe |
| Pete Fitzpatrick | Paul Wagner |
| Wendy Fuller | Joseph Weston |

of Princeton Architectural Press
—Kevin C. Lippert, publisher

Library of Congress Cataloging-in-Publication Data

Kroeger, Michael.
  Paul Rand : conversations with students / Michael
Kroeger ; texts by Philip Burton ... [et al.].
    p. cm. — (Conversations with students)
  Includes bibliographical references.
  ISBN 978-1-56898-725-5 (pbk. : alk. paper)
  1. Rand, Paul, 1914–1996 2. Graphic arts—
United States—History—20th century. I. Rand, Paul
1914–1996 II. Title.
  NC999.4.R36K76 2008
  741.6092—dc22

                                2007015219

Table of Contents

Foreword

In 1968 I started teaching typography at the Basel School of Design in Switzerland. Paul Rand came once with Armin Hofmann. Down in the basement of the darkroom of the lithography department, I felt honored to meet with an internationally known design personality from a country that, I thought, had skyscrapers in every village.

The handshake ritual was combined with a question: "Is this the crazy Weingart, Armin?" I was twenty-seven, and only a few insiders knew me as the "crazy man," but Rand knew everything, all the insiders' secrets.

Over the next twenty-three years, I met students during the Yale Summer Program in Graphic Design, in Brissago, Switzerland. Everyone had a story about their teacher Paul Rand. Since the stories were often quite contradictory, I became more and more intrigued with this unique, mysterious person.

Philip Burton, one of my first students at the Basel School of Design, was teaching typography and graphic design at Yale, and so, in April 1986, I had the opportunity to teach for a week there—the first-year class. Paul Rand could not attend my opening lecture—driving his car was becoming increasingly problematic because of his eyes.

But then Burton received a surprising invitation: we were both asked to Rand's house in Weston, Connecticut—which he designed and worked on from 1952 until his death—to give him and his wife Marion a private lecture. The evening was combined with a wonderful dinner, and over the course of the evening, all of the stories that I had in my mind about the Rand family became irrelevant. We began a friendship that lasted until November 1996, when he died in Norwalk, near his quiet home surrounded by tall trees.

We met regularly in the United States or in Switzerland. During his few visits to Basel, we were twice able to invite him to our school, to bring him and Marion together with my students in the typography classes. These events were highlighted by his intelligent and humorous lectures.

Through the years we discovered a common love of children's books. Between 1956 and 1970, he illustrated and designed four books for the legendary children's book editor Margaret McEldery at Harcourt Brace and World: *I Know A*

*Lot of Things* (1956), *Sparkle and Spin* (1957), *Little 1* (1962), *and Listen! Listen!* (1970). The text was always written by his second wife, Ann. I was also creating children's books, for children in Jordan and Pakistan.

Tom Bluhm, a student and friend of Rand's for many years, would sometimes visit with me. He would bring me some of the materials that Rand wrote and designed as presentation booklets for different companies. One of the booklets described the development of the logo for Steven Jobs's company NeXT Computer in Palo Alto, California. In these he helped the companies understand his research into different typefaces and their transformation into the definitive mark. I was always impressed with how clear, concise, and complete his explanations were. Even with my bad English, I could understand every sentence.

Rand was for me one of the strongest, most important warning voices about the future of design and the world we inhabit. His attitude was honest and direct. I believed in what he had to say, and we shared many opinions. He delivered his last lecture (organized by John Maeda) in early November at the Massachusetts Institute of Technology. His lucid and relevant delivery in the packed auditorium was about form and content in art and design, the focus of his last book, *From Lascaux to Brooklyn* (1996).

Wolfgang Weingart

1

# Preface

I first met and studied with Paul Rand in Brissago, Switzerland, in the summer of 1981, during a five-week workshop that also included individual one-week sessions each with Philip Burton, Armin Hofmann, Herbert Matter, and Wolfgang Weingart. The assignment for Rand's class was a visual semantics project with painter Joan Miró as the subject matter. The object of this problem was the manipulation of words and letters to illustrate an idea or evoke some image— specifically, to suggest by means of the letters M I R Ó the work of the painter. One of my solutions was a playful design with letterforms depicting an image of a cat with the name Miró. Rand was quite helpful with this final design. (Figure 1)

I was pleased to talk with him briefly during his visit to Arizona State University (ASU) in February of 1995 and have lunch with him and his wife Marion. The ASU Eminent Scholar Program sponsored his visit to the School of Design, to lead a classroom discussion with and offer a lecture to the students in the graphic design program. We also presented some of our student's work from Professor Thomas Detrie's letterform class and my visual communication class. Rand critiqued this work: "It is not better or worse than other design schools" he had visited, which I took as a compliment.

The topics covered were varied, but the focus of conversation was design and an article I was working on at the time on my website called "Graphic Design Education Fundamentals." Subjects also included during these talks were graphic design, design philosophy, and design education. The following excerpts are from these meetings.

## Acknowledgments

I would like to thank Paul and Marion Rand for their time during the 1995 interview at Arizona State University. My most sincere gratitude goes to Philip Burton, Steff Geissbuhler, Jessica Helfand, Armin Hofmann, Gordon Salchow, and Wolfgang Weingart for their lovely articles and thoughts on Rand. I would like to thank Linda Lee, editor at Princeton Architectural Press, for all of her help during this process. I would also like to thank my three brothers, Greg, Steve, and Jim, for their help and support over the years. Finally, I express deep appreciation to my mother, Mary, and father, Douglas, for all their love and support.

"Design is relationships. Design is a relationship between form and content."

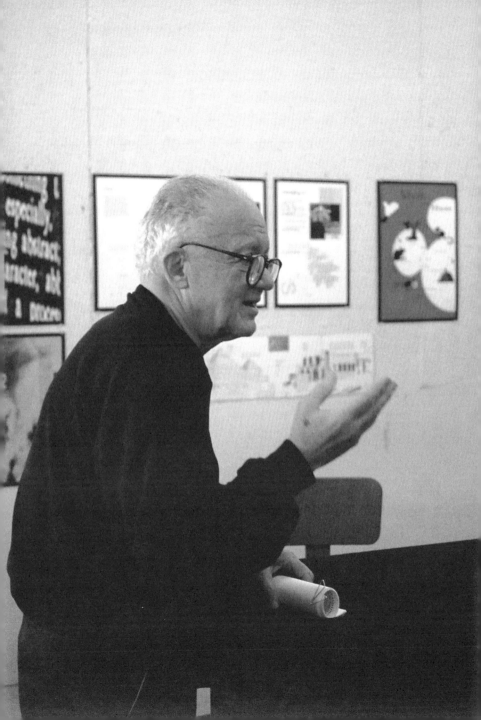

**Michael Kroeger** I brought in a couple of the books that you recommended the other night at the lecture.

**Paul Rand** Oh yes, this book is familiar.

**Kroeger** I started reading the first chapter of Dewey's *Art as Experience* (1934).

**Rand** You did? That is pretty good? How long did it take?

**Kroeger** Well a couple of pages each night. It does not go very fast. This is the other one we talked about, Doren's *A History of Knowledge* (1991).

**Rand** This is very good, a summary, and very knowledgeable. It is not just a guy who abbreviates things, the guy writes novels. He is the guy who was caught in 1964 on the television show *Twenty-One*.[1]

Students should know about these things. It is a good book to read. A good reference book. But if you are going to start a bibliography you have got a lot of books.

**Kroeger** You said during your lecture the other night that you have six pages of references in your latest book. (Figure 2)

**Rand** Yes.

**Kroeger** Is this John Dewey book in there?

**Rand** That is one of the books. Well, you are just not an educated designer unless you read this book or the

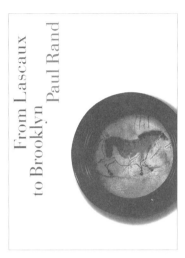

From Lascaux to Brooklyn    Paul Rand

2

equivalent. You are just not educated. I mean, you just don't know.

**Kroeger** He talks about, in the first chapter, the artistic and aesthetic approach intertwined. He said he could not find a word that combined both of those terms, or the aesthetics of art.

**Rand** Well you can talk about it, there is a lot to talk about. This first chapter I think on the very first page he says,

> By one of the ironic perversities that often attend the course of affairs, the existence of the works of art upon which formations of an esthetic theory depends has become an obstruction to theory about them. For one reason, these works are products that exist externally and physically. In common conception, the work of art is often

identified with the building, book, painting, or statue in its existence apart from human experience. Since the actual work of art is what the product does with and in experience, the result is not favorable to understanding. In addition, the very perfection of some of these products, the prestige they possess because of a long history of unquestioned admiration, creates conventions that get in the way of fresh insight. When an art product once attains classic status, it somehow becomes isolated from the human conditions under which it was brought into being and from the human consequences it engenders in actual life-experience.

This is the essence of this whole book, this paragraph. That art is a thing you do not experience but you have to go into a museum to find it. He says that art is everywhere.

**Kroeger** Art in the museum is a fairly recent development.

**Rand** Museums have separated art from normal experience. The answer is in the problem. The problem is that it is isolated from where it should be. Art should be in your bedroom, in your kitchen, not just in the museums.

It used to be when you went into a museum there was nobody there. When I went into art school we used to go and

paint in a museum—nobody was ever there. But now it is impossible.

**Kroeger** Do you think people are searching for something to give meaning to their lives?

**Rand** I do not know; do not ask me. You will have to ask a psychologist. This book (*Art as Experience*) deals with everything—there is no subject he does not deal with.... This is his most famous book. All your students should read it.

(Figure 3)

**Kroeger** How do you relate reading or can you relate your experience to designing?

**Rand** You do not. It is like eating bread—it is nourishment when you run—you do not eat bread [while you are running], but there is a clincher here that you may not like.

3

Kroeger That you may not be a good designer—by just reading this book.

Rand Being able to do something, explain and understand what you are doing—it is like sitting in an easy chair. It is like what Matisse said, do you understand? It leads to something.

Kroeger I want to talk about these early stages of design. (Figures 4–8) The basic foundation—what would be an approach to graphic design education. This is how I start: line interval studies, color problems, get the students familiar with composition. (Figures 9–17)

Rand Why do you call this curved line and curve shape? It should be curved. Curved line, one passive, one active, which is passive, which is active? (Figures 18–20)

Kroeger The idea is to relate the forms to each other. The passive form is relative to the active form within its context. The other examples are color studies: wet and dry, hot and cold, good and evil, and tumble and hide. (Figure 21 & 22)

Rand I know. How is this wet? How is this dry? You are just saying it. It does not look wet. What is the difference? This stuff is difficult stuff to do. You are involved in very complicated philosophy and psychology. Wetness to one person may be dryness to somebody else. (Figures 23–26)

Everything is relative. Design is relationships. That is where you start to design. Do you say what design is? That is important. If you say design is relationships, you are already giving them something. That is very basic, and they do not already know about it when they read this stuff. Without knowing the basic theory, people feel they have to memorize everything. It is impossible.

Kroeger That is what I am trying to approach. What is the best way to teach design to undergraduate design students?

Rand You have to define all your terms. You have to define what design is. Do you know what design is? What is design? People have to understand what the hell they are doing. In art school people assume everybody understands everything. They do not. You talk about

Ground grid structure

4. Checkerboard     5. Floating     6. Gradation     7. Rhythm     8. Motion

**Vertical-line-composition development: five black and four white lines**

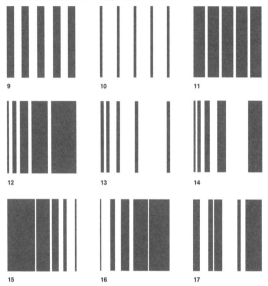

9. Even / static
10. Static / white dominant
11. Static / black dominant
12. Progression / black increases, white remains same
13. Progression / white increases, black remains same
14. Progression / white increases, black increases, same direction different rates
15. Progression / black decreases, white increases
16. Progression / white decreases, black increases
17. Random line composition using common elements from the matrix
18. Two shapes, passive compared to active
19. Passive, active, more active, with an addition of a linear element
20. Passive to extremely active (five edge elements)

**Organic, curvilinear form development**

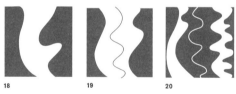

**Word communication with ten square elements**

21. Tumble    22. Hide

23. Cold

24. Wet

25. Dry

26. Hot

UCLAB
CDEFG
HIJKLM
N PQR
UCLA Summer Sessions   1993
STUVW
University of California, Los Angeles   310 825 8355
XYZ93

27

design and there is no definition, and everybody has different ideas about what design is. One person thinks of his father's tie. One person thinks of his mother's nightgown. Another person thinks of the carpet in the living room. Another person is thinking of his wallpaper in his bathroom. You know? That is not design. That is decorating.

What is the difference between design and decoration? The basics are very important! This is not basic. There is nothing basic about this stuff. This is really sophisticated stuff. I do not know how it was taught in Basel. I suppose it was done by example, not by theory.

**Kroeger** We can point to design. This poster is good design. The chair is a good design. (Figure 27)

**Rand** Everything is design. Everything!

**Kroeger** Then what do we have? We have good design or bad design?

**Rand** That's right.

**Kroeger** Then how do we decide?

**Rand** You ask questions that are not answerable. There are a priori notions about things that are self-understood. Everybody agrees. There are things that are not a priori, things that do not agree. There are things that you agree, you know, you go out, the sun is shining, everybody agrees, very pleasant. When

it comes to illustrating wetness or dryness, that is something else.

You have to establish a relationship. It has to be related some way to something that gives you a clue. You have to have some visual clue. This is how you show wetness and dryness. You do not do it the way you did it. That is not possible. Unless you explain it, that is not explained.

Now if, for example, you have a pattern of white dots on a black background, there is an idea of wetness by association with raindrops. So there are all kinds of associations that come into the picture. You are dealing with a very complicated subject. (Figure 28)

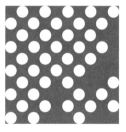

Paul Rand's idea of wetness, realized by author

28

**Marion Rand (Paul Rand's wife)**
It strikes me that there must be some books that you could find. Books that would explain the foundation of design.

**Kroeger** Kepes's *Language of Vision* (1969)?

**Rand** No, no, no! That is philosophical double-talk.

**Marion:** Not Kepes.

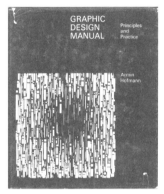

29

30

Rand There is no book but Paul Klee's *Pedagogical Sketchbook* (1953), but that is very difficult. It is rooted in the Bauhaus.

Marion: There must be guys in this country that are teaching this. Something that has basic materials that they use. What do you think, Paul?

Rand Do you know Armin Hofmann's book *Graphic Design Manual (Principles and Practice)* (1965)? They are not study books—you know they are just examples with little captions, but they are better than nothing. But beautiful stuff, I mean everything is beautiful, you know?

(Figures 29 & 30)

Kroeger Everyone just tends to copy that because they do not understand the theory behind it.

Rand Well, I think you can get a pretty good idea if you look at it. I learned by looking at pictures. I would not sit down and write a book, a basic book. That is

some job to do a really good book.

Kroeger There are no good textbooks to use. We show examples of good work, and we give the students lectures on the history of design. (Figure 31)

31

Rand I think you can do it by example. You show. You take Armin's book, make blow-ups, put them on the wall, and discuss them. But basic stuff, like the principles of a grid. You know the principles of grids? You do?

Kroeger The grid like in Müller-Brockmann's book *Grid Systems in Graphic Design* (1961)?

Rand Yes that. There are lots of mistakes in that book. You know the book?

Kroeger His work is so mechanical that, I do not know, he falls in that rigid pattern of staying in the grid. Müller-Brockmann stays in the grid so much. He does not come out of it. Not everyone can do that.

Rand Well, that is not the point. The point is not to come out of it. The point is to stay in it and do it right. The reason people want to come out of it is they do not know what they are doing when they are in it. The idea of the grid is that it gives you a system of order and still gives you plenty of variety. It is up to you when you want to switch. So a square can be this big, or this big, but here you are all over the place. I mean this has nothing to do with grids anymore, and you think you are doing something great just because you are getting out of it.

Kroeger I would not say great.

Rand Then why do you do it? I mean there is no reason for it. I will show you the basis for a simple grid and how you do it. This one way that you are talking about, where everything is the same. Right! This is another way. There is the difference between this and this. Sometimes you do this. Sometimes you do this. And you go on from there, you know this becomes this, then it

32

becomes this. But the grid never changes. It is always the interior that changes, and that is what makes the thing come alive. (Figure 32)

Kroeger Does that refer to Whitehead's statement about conservation and change? [2]

Rand Well, I guess it does, but I was not thinking about Whitehead. This is common sense.

Kroeger But it does apply, you have the conservation of the square and the change within.

Rand That is more like unity and variety. Now if you did nothing but this, you know, it would be boring again. But then you go on forever changing these things. I mean, this is what is essential.

It is absolutely basic, and very few people know or talk about it. I have never seen it talked about.

**Kroeger** Why do designers not talk about these things?

**Rand** Well, because they do not know. It is not because they want to keep it a secret. They just do not know. But if you look at these things and you try to figure it out, well, maybe you can figure it out. And then you know, I mean, it is no mystery. It is obvious. This is part of Gestalt psychology. You know the difference between the part and whole, that the whole is greater than the sum of its parts. The whole business of what happens to things, there are lines, figure/ground problems. These are all Gestalt psychology problems, all these things you do are figure/ground problems. Everything is! (Figures 33–35)

**Kroeger** Even the more sophisticated projects.

**Rand** There is nothing saying it is more sophisticated, all projects are sophisticated. You see, first of all you

have to draw the grid. You have to decide these dimensions. That is important. Mechanically, the grid is based on your typeface. Consider the size of the type and the leading. There is no reference to it here at all. All of a sudden you go from this to this, then you mix it up, you mix up conventional type with sans serif, in here. Why?

[None of this means] anything to students without understanding what they are trying to do, without understanding what design is. What is design? Do you know? Do you have a definition for design?

**Mookesh Patel (Associate Professor / current Chair of Visual Communication at ASU)** For me it is a process of design, being able to translate problems of communication to a person that you are trying to reach.

**Rand** Yes, but that is not what design is. That is just telling me what you have to do. That does not tell me what design is.

**Patel** As a noun it is a plan—

**Rand** A plan of what?

Figure / ground problems

33          34          35

**Patel** It could be a plan of anything, as design.

**Rand** What do you do with your definition? What does a student do with a definition like that?

**Patel** With the plan, what do they do?

**Rand** Nothing.

**Patel** They try to understand the difference between—

**Rand** Now wait a second. You said that design is a plan. Now what does a student do with a definition like that? Practically nothing. A plan, a blueprint, period. Nothing. That does not generate any future possibilities.

**Patel** So how do you think we should proceed?

**Rand** Well, I am asking you, there are many definitions for design, but a plan is a dictionary definition, like a definition of aesthetics. Aesthetics is a philosophy of beauty. So what? What do you do with that?

There is a big difference in definition, a big difference in defining terms. You ask a student, what is this? The student answers, and it is correct, but it does not lead you anywhere. So a definition has to lead you somewhere, it has to generate something.

**Kroeger** The solution? The next step? What does it generate?

**Rand** You have not even defined it. So how can you know what it generates? If you define it, it generates automatically. What is aesthetics? I mean you have been reading Dewey, why not look it up?

**Kroeger** Well, he defines aesthetics. In the art process, you have making and doing of art, and when that stops—

**Rand** That is not a definition of aesthetics.

**Kroeger** The art is the doing and the making of things and the aesthetics is the appreciation and observation of that thing which has been created.

**Rand** And what does that mean? The appreciation? You appreciate something. Does that mean you understand it or that you like it? Anyway, we still have not decided what design is, or you have not. (Ha, ha, ha.)

All art is relationships, all art. That is how you have to begin. That is where you begin. Design is relationships. Design is a relationship between form and content. What does that mean? That is how you have to teach it. And you have to teach it until they are absolutely bored to death. You keep asking questions. You have to understand before you ask the questions. So, if I say relationship, what do I mean by that?

(To Patel) OK, you are standing there. You have gray: gray shirt, gray lines, light gray, dark gray. You have a

you put something down you have created a relationship—good or bad— most of the time it is lousy. You see?

**Kroeger** Is that why nobody has done this before?

**Rand** Done what before?

**Kroeger** Try to put these design ideas down in one place. (Figure 36)

**Rand** I am the only one that has done what I have done so I do not know, all over the world, I am sure someone has done it. I do not worry about that. If you worry about that, you will never do anything. Because it is likely that someone has already done what you have done, more likely than not. So when I do something, I do not worry about that—unless I know its been done—then I would be stupid to do it again. That is the reason, when I do something, when I quote somebody, I get footnotes, so they can read it for themselves. I do not assume, like most writers. Most writers do—they do not even quote. They pretend everything they write down is their own. It is not. It is a lot of work.

**Patel** Culture is a big issue. There are certain things that are culturally appreciated in one culture but not in another. How do you see that? How do you evaluate that difference?

**Rand** Well, give me an example.

36

whole symphony of grays. These are all relationships. This is 20 percent, 50 percent, these are all relationships—got it? Your glasses are round. Your collar is diagonal. These are relationships. Your mouth is an oval. Your nose a triangle— that is what design is.

Now if they do not understand that, they do not know what the hell they are doing. They are just making mechanical drawings. Everything here is a relationship. This to this, this to this, this to this, everything relates, and that is always the problem. The moment

37

Patel Swastika. In one culture it is very good, in another culture it is bad.

Rand Yes, but you're not talking about design, you're talking about semiotics, the meaning of symbols. That has nothing to do with design.

Patel Here is another thing, the example of the design forms in how you appreciate the whole. The something you find in other cultures, you would not find aesthetically pleasing. So how do you see the difference, or evaluate the difference?

Rand Well, you are not, you are concluding it is not aesthetically appreciated. I think that it is a question of symbols. It has nothing to do with aesthetics, in fact. I think that for the general public, and for most people, aesthetics is not an issue.

To appreciate things aesthetically means you really have to understand aesthetics, because that is what you are doing when you look at a picture. You are recreating it. If you are aesthetically oriented, you recreate this picture. A picture is constantly being recreated by you or whoever is looking at it. The same thing has to do with design—there is no difference.

Patel As design professionals most of the time—

Rand Well. That is the problem you have with being a designer and dealing with clients. I assume that is one of the problems. You do not look at the problem the same way. So you double-talk, triple-talk, do everything under the sun, stand on your head to make a point, because you are not talking about the same thing.

Kroeger Dealing with the client's aesthetics, as opposed to—

Rand You do not talk aesthetics to the client.

Kroeger Because his wife might like purple.

Rand That is right. If you're lucky your client's wife will not like purple. (Ha, ha, ha.) But who knows? Aesthetics is the only thing you can talk about. Just as being a designer is a conflict between you and the problem or you and the client, and so is design, it is a conflict between form and content. (Figure 37)

Content is basically the idea, that is what content is. The idea is all of

those things. Form is how you treat the idea, what you do with it. This is exactly the meaning of design: it is the conflict between form and content, form being the problem. I mean how you do it, how you show something, how you think, how you speak, how you dance; choreography is the content, it is the dance itself. In case this appears too simple to you.

**Kroeger** Ha, ha, ha.

**Rand** It is not simple, but on the other hand it is simple. It is the coming together of form and content that is the realization of design. That is as good a definition that you can get anybody to give you. And you will not get it in a book.

**Marion** I guess it is time for us to go, the group is here.

**Rand** I am already worn out from this session.

**Kroeger** I really put you through the ringer.

**Rand** If I have nothing to say it is because I am exhausted.

**Kroeger** We could play the tape and you could listen.

**Rand** Not that.

Notes

1. Charles Van Doren was a Columbia English professor who became a winner on the quiz show *Twenty-One*. However, he admitted to cheating and being fed the answers at a House Committee on Interstate and Foreign Commerce hearing in 1959. He resigned his professorship at Columbia University in 1959.

2. "There are two principles inherent in the very nature of things, recurring in some particular embodiments whatever field we explore—the spirit of change, and the spirit of conservation. There can be nothing real without both. Mere change

without conservation is a passage from nothing to nothing.... Mere conservation without change cannot conserve. For after all, there is a flux of circumstance, and the freshness of being evaporates under mere repetition." Alfred North Whitehead, *Science in the Modern World*, Lowell Lectures, 1925 (New York: Macmillan, 1926).

"I think it is important to be informed."

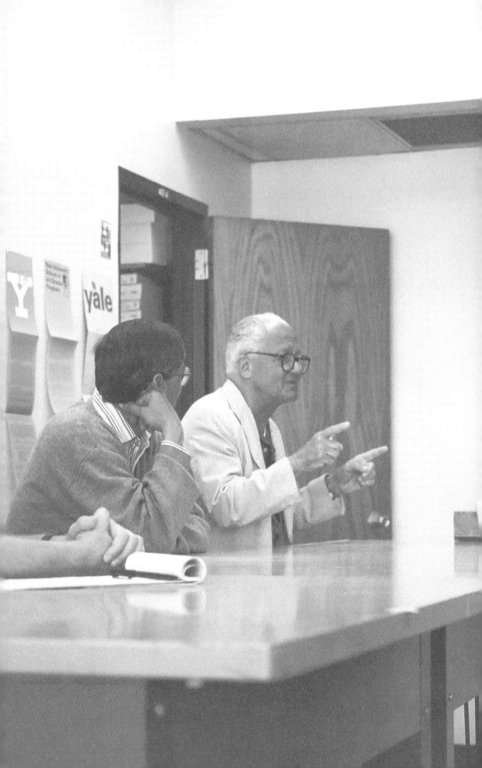

I B M

I B M

I B M

*Composer Ribbon*

I B M

**Paul Rand** What do you do with that, anybody?

**Student** Communication can create cause and effect.

**Rand** That is correct too, but it does not get us anywhere. Anybody else?

**Student** Communication is cause and effect.

**Rand** Communication always causes an effect. It either puts you to sleep or something. Try again.

**Student** Design manipulates and leads you somewhere.

**Rand** That is better. It leads you somewhere.

**Student** Design is two-dimensional.

**Rand** Why does it have to be 2-D or 3-D—why can it just be anything? So manipulation is part of it—at least we know we have to manipulate it. What are we manipulating—yes, what else?

**Student** Form and content.

**Rand** Design is the manipulation of form and content. With that kind of a definition you know you are going somewhere, you are doing something, so I sit down and I manipulate. What does that mean to manipulate? What do you do? The process you go through is that aspect of manipulation. What you are doing.

Content is the idea, or subject matter. Form is what you do with this idea. How do I deal with it? Do I use color? Do I use black and white? Do I make it big? Do I make it small? Do I make it three-dimensional or two-dimensional? Do I use trendy stuff, or do I use more serious stuff? Do I use Bodoni or do I use Baskerville?

These are all questions you ask. This is part of the manipulative aspect of design. So in order to have a discussion about a subject, it is necessary that you define what we are talking about. Most of the time people talk about design and nobody understands what the subject is. Nobody ever thinks about it. Somebody thinks about design as something he saw in a tie design or bathroom wallpaper or a pattern in a carpet. That is the general understanding of what design means. That does not mean design. That is a part of the design process, but that happens to be just decoration. This is how most people define design. This is how a layman defines design. I think it is an unfortunate word but nevertheless it is the word we are stuck with. It goes back to the pre-Renaissance when [artist and architect Giorgio] Vasari said that design is the fundamental, the basis for all art, painting, dance, sculpture, writing—it is the fundamental of all the arts. It is the manipulation of form and content in all the arts.

So design, and graphic design, is no different from design in painting. If you carry this idea to its natural conclusion, you will decide that there is no difference between design and painting, or design and sculpture, it is all the same. If we have any painters in here, I am sure they violently disagree, but it does not matter. Bring up a painter. You know somebody who is a painter, bring him in.

**Student** I do paint but I completely agree.

**Rand** OK, so I can leave now.

**Student** Same form, same color, the same problems.

**Rand** If you are a lousy painter then you are a lousy designer. Right?

**Student** I hope not.

**Rand** I said if. OK, I think we understand what design is. Another kind of definition is that design is a system of relationships—so is painting. It is the relationships between all of the aspects of a problem, which means the relationship between you and the piece of canvas, between you and the cutter, or eraser, or the pen. The relationship between the elements that are part of the design, whether it is black or white, or line or mass.

It is also a system of proportions, which means the relationship of sizes. I can go on all day, and so can you, when you think in terms of relationships. They are endless. That is one of the reasons design is so difficult to accomplish. Because every time you do something, the potential for making mistakes is enormous. The process of designing is from complexity to simplicity. The part of complexity is filled with all kinds of horrible problems. Then trying to evaluate and weigh all these problems to make it simple, this is very difficult.

I think Picasso said that painting is a process of elimination, which means you have to have something to eliminate. That is one of the reasons we start off with things very complicated. But the product must end up being simple. That is difficult for anybody. End of lecture!

**Steve Ater (former Assistant Professor of Graphic Design as ASU)** One of the questions I would like to ask is what is important for us to study in order to teach graphic design in a university or high school? What is important that we learn?

**Rand** I think it is important to be informed. It is important to know what you are doing. It is important to define and be able to define your subject. It is important to know, in your case, the history of graphic design and the

history of art, which is the same history. It just goes off a little bit to the side. It is important to know aesthetics—the study of form and content—which we also attribute to design. [Aesthetics and design are] the same things. Aesthetics is the study of design, the study of relationships, and it is very complicated.

I always recommend that people read; very few people want to read. Especially if you get Dewey's *Art as Experience* (1934), even out of the library. After the first sentence you will put it down and forget about it. If you do not want to read that, read Monroe Beardsley's *Aesthetics: Problems in the Philosophy of Criticism* (1958), about two hundred pages longer. There are several others even longer. There is Hegel's *Aesthetics: Lectures on Fine Art* (ca. 1820), which is over a thousand pages. But I really think that unless you have read *Art as Experience*, you have not been educated in design. I warn you that you will probably put it down after the first sentence. Those who read it will prevail and be very thankful. Does that answer your question?

**Ater** If we are going to start to study design, what sort of things would beginners learn? What is important? Should they use materials like plaka and cut and torn color paper? (Figures 38–42)

**Rand** Absolutely. It is important to use your hands, that is what distinguishes you from a cow or a computer operator. I do not want to leave the impression that I am against computers because I just finished my book and it consisted of roughly two hundred pages and every page is done on the computer. I did not do it. The computer work was done by somebody who can use it. I am too old for that stuff. Every time I start, you have to do this and do that.

When the computer was first introduced at Yale University, I considered that a calamity. It is not because I am against the computer. I am not. I think they are unbelievably astonishing machines. But that quality in itself—that seductive quality—is also what is bad about it. Especially for beginners, who have to learn the basics of design. If you have to read Dewey and work on a computer, that is a rather tough problem. You have to decide which is more important. If the computer is more important, you will wind up—if you are a very good computer operator—in an advertising agency sitting at the computer for the rest of your life. That is because you will be getting better at it every day. You get more useful to your boss, so you will never do any designing.

Hand skills / form development (with gouache and brush only)

38. Hand form

39. 3-D paper form

40. Bell-pepper form

41. Convex / concave form

42. Leaf form

A student from RISD [Rhode Island School of Design], who worked for me, actually did my book on the computer. Now I got him a job—at a very big advertising agency in New York—and that is what he is going to end up doing. He came to work for me to do design. So I think that it is very important that you regard the computer properly, and put it in its right place.

The fact that you can use the computer and all the systems, the Quark, all that other stuff, it is very unimportant compared with the problem of understanding what you are doing as a designer. That is because the computer will not teach you how to be a designer. NO WAY! You know that when the typewriter was invented, its greatest accomplishment was that it destroyed handwriting. If you look at early handwriting manuscripts before the typewriter existed you will see what I mean. I think—and I am not Nostradamus—but I think that something similar is going to happen to art because of the computer. I think that relationship is an adverse one. I could be wrong, but that is what I think.

**Student** We talk about process—the way we design.

**Rand** This has nothing to do with the definition of design, but how you or anyone in the creative field work? Graham Wallas (*Art of Thought* [1926]) was smart enough to invent this notion

of getting an idea, investigating all the aspects of the problem, making sketches—rough or finished—and then forgetting about the problem, just forgetting it. This is the first part of the process, called preparation.

The second part of the process is incubation. You forget about it, and let it incubate. Let it simmer in your mind. This is not anything I invented. This is some very bright guy discovering how these things work. I know that it works in my case, that if I do something and I am having problems with it I forget and come back to it the next week or the next day and something happens. So the incubation period is very important, to forget for a week, or a day, or whatever. You take the time so you can decide.

The third aspect of the problem is revelation, or illumination. You know, you waited a week and all of a sudden there is a revelation. You get an idea. At that point you put it down and see if the idea corresponds with what you would like to do. After you get it all down, you look at it and you evaluate it. You see if it works, if people agree, or if you disagree.

So that is the design process or the creative process. Start with a problem, forget the problem, the problem reveals itself or the solution reveals itself, and then you reevaluate it. This is what you are doing all the time. (Figure 43)

**Student** So when you design, a solution does not just come to you?

**Rand** Well, sometimes it does if you are lucky. It is rather rare. Sometimes you think it does. I mean, you think you have got a great idea and it is not so great. But that is the process. If you are talented and honest, you look and you say, that is lousy, forget it, and you start all over again. That happens all the time, or you redo a job; I rarely have done a job that I did not redo maybe ten times. Disgusting, is it not? It is the way it is and I have a lot of experience.

**Student** This process thing—do you think it is possible to come up with a perfect design?

**Rand** I think if you are God it is. No, it is not possible because if design is a system of relationships, then every single relationship has to be perfect. And how is that possible? Maybe the color of the green is too bright or too dark. Maybe the gray is too washed out. Who knows? Maybe there is too much green or too little gray, or whatever. Maybe in the case of Michelangelo's God's pointing finger, it would be better to have it point this way or up here. Who knows?

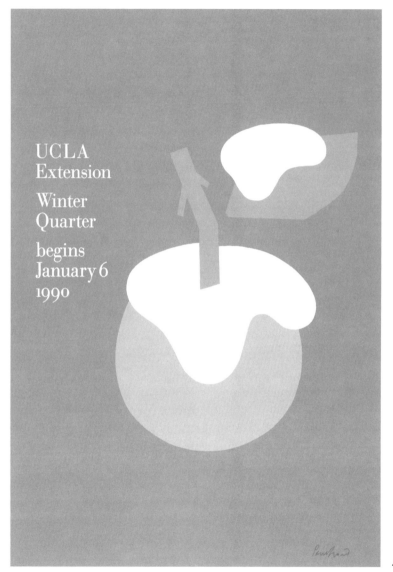

UCLA
Extension
Winter
Quarter
begins
January 6
1990

Paul
Rand

Design
Form

and
Chaos

44

satisfaction of solving problems is enormous.

That is why you have to understand what you are doing, and you have to understand when a problem is a problem. If you do not know what you are doing, how do you know if you have a problem? You look at it and you do not like it, but you realize that there are such things like proportion and contrast and texture and all of these things. Then you check these things out. Oh yeah! I do not like this proportion. There is too much of this and too little of that.

**Student** So can a problem be solved?

**Rand** You mean can the idea be there but the form cannot be resolved? Oh yes, that is most often the case.

**Ater** We have an example in front of you.

**Rand** The FedEx logo would be a very good problem for your kids in class. How can you improve this? Start over. Do you think it is perfect? What is wrong with it? Do you know what is wrong with it? You have these styles mixed, which is ridiculous. You do not mix typefaces. It is stupid. That is mannerism, trendy stuff, doing it because someone else is doing it. The only reason to do it.

In our business there is an insidious thing called "making a living." There are a lot of studios that have a lot of people who have nothing to do, so

**Student** So unless you are God, it can never be perfect. Do you think it is right to never be satisfied?

**Rand** Well, I am afraid I have to agree it is a rather bleak future. I am afraid that is the way it is. I never stop changing what I do until the thing is printed, which includes my books. (Figure 44)

**Student** Would you say it is hard to find satisfaction in design?

**Rand** Oh no! Not at all. I would say just the opposite. When you solve a problem, you think you are in heaven. You might change your mind later on, but you have already had the opportunity to think you are in heaven. That does not have to last too long. Can you think of another job that would give you that satisfaction? The

they [make up projects] to keep them busy. So what they will do is criticize other design studios or write letters to clients. They approach my former clients and try to convince them to change their design. That has happened to me many times. A design studio decides to redo the ABC account, for no other fact than they wanted to get a job and keep their studio busy. (I did not expect to be getting into this.) They made a survey and discovered that of the three or four big broadcasting companies—ABC, NBC, and CBS—that ABC did not have something [in its logo] that is alive. There was no chicken or coots or eyes. It was something inanimate.

If you follow those precedents, you would decide to get something animate in there—a snake or a rabbit or something. In the end the company was bought by one of these conglomerates. The client was worried; he hired a bunch of designers to do new logos. This is true, and for some reason—I never saw what they did—but they were rejected. Another guy from an advertising agency decided, well why not go to an art school, you know like this one [ASU]? Maybe there is some genius running around, you know, like Mozart, or Hayden, or Beethoven. Maybe this is the way to do it.

Well, they did it and got nothing but junk. After all that they decided to do market research on the ABC logo that I did; the results were enormously favorable to the company because it has enormous recognition, almost 100 percent recognition. They immediately stopped the market research and redesign process. That is the reason you still have the ABC logo as I designed it in 1962, except that they are screwing around with it. They make it thin and ruin the drawing, but it is still ABC. This is what happens in our business. (Figure 45)

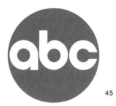

45

Now this FedEx problem that is not resolved—so what is wrong with it? I think you should give this as an assignment. I mean what is wrong with it? Anybody?

**Student** They try to make the typography too...

**Rand** I think that is the least of it. I think it is legible enough. That is the least of it. What is wrong with it that is psychological, that is not aesthetic? What about the design? What do you

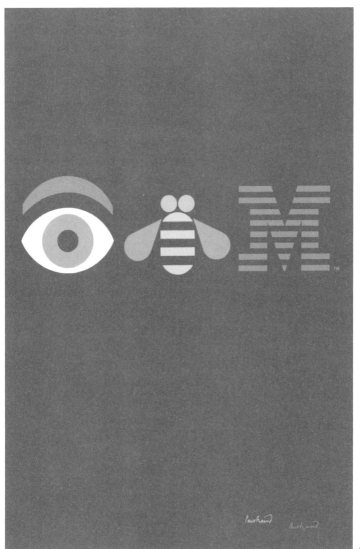

46

do basically when you have a logo to design? There are a lot of letters that you have to deal with. What is the first thing you have to do?

**Student** Look for relationships of one letter to another?

**Rand** Well you always do that, but what else do you do? What is the first thing you do if you have a very long name like Tchaikovsky? You abbreviate it. Well, that is what they did, but that is not usually the solution, because a client does not want his name abbreviated. It is easy, easy, easy, easy, come on.

**Student** You squish it together.

**Rand** How do you squish it together?

**Student** With leading.

**Rand** Leading? It is this way, not this way. What do you do? Condense it. Right! You condense the letters. That is the first thing you do. I mean it not only reduces the bulk in area, but it is much more practical because it can be accommodated in small spaces, which is always a big problem with a logo. When you design a logo you think in terms not of how big but of how small, down to $^3/_{16}$ of an inch. That is the physical process of designing a logo.

So the wider the form is, the more difficult it is to reduce. Not only that, but in condensing it you—what does that do when you condense it? Talking only

47

aesthetics. What does it do aesthetically? What else? You alter the proportions; you make it a simple object, something that is self-contained. The smaller it is the more self-contained it is. For example, that is the idea of a coin, you know? It is a little round thing. So you are giving it more presence. Something that spreads has less presence. It has physical presence. But it does not have aesthetic presence, you do not concentrate, there is no bulls-eye. (Figure 46 & 47)

**Student** It becomes more intimate.

**Rand** Yes, exactly. This is how you have to think about these problems—and not about design. The design i s the product of your thinking. The solution to these problems comes in a second. But before you have focused these thoughts, you are all over the place, because you are searching. You are feeling. You are look-ing for things. You do not know what you are doing. You are lost. You are in a maze. So thinking is number one in the design process.

Now there are people who can look at something and figure it out in a minute. I can do things pretty fast, but

the problem I have is with process—how I am going to do it, not what I am going to do.

The arrow, for example, in the FedEx logo was a great idea, but it becomes part of the background, so you do not even see it. It is because the figure/ground relationship is lost. So, obviously, the easiest thing to do is to make it blue in this context, just make it blue. Now I cannot imagine that somebody did not try this, whoever did this. I just cannot imagine that, but it is possible—people avoid the obvious thing.

You know Goethe said—to paraphrase—that we do not see the things nearest to our eyes. This is true. When you get an idea you wonder why you didn't get it yesterday instead of today. You just did not. Well, with all this talk I can leave you with the notion that getting ideas is not easy. It is very difficult to get good ideas, and it is also very difficult to figure out how to execute them. So you've really got yourself a job.

**Student** Which do you think is the hardest, getting the idea or putting the idea down?

**Rand** It could be either one, it depends on the problem. Sometimes if you get lucky, you might get a series of letters that lend themselves to interpretation very quickly. Then on the other hand, you get a word that has nothing but vertical lines. That is very difficult to deal with, but that in itself becomes the subject for an idea. You say, it is all vertical lines, I need some round shapes, so you mix caps and lower cases. There are more round letters in lower cases than there are in caps. The problem is always derived from the subject; the solution is always hidden somewhere in the problem, you know, somewhere, you have to look for it.

**Ater** One of the other questions. With the new problems we are faced with, we have problems that are different from when you were starting. How do we go about solving these problems?

**Rand** I do not think problems are different. If you are talking about social problems, and teaching problems this is something else. But design problems are no different. They have always been difficult. Good design remains good no matter when it was done. I can show you logos that were done in the 1900s that look as if they were done yesterday. Why is that? Design is not dated. Design is universal and timeless, good design.

Can you imagine that if the theory that good design has to change

constantly was true, we would all be miserable. Every time you go to a foreign country and see all these old buildings, you would want to tear them down. Right, because you would expect them to be new everyday. That concept is so stupid and so ridiculous—newness has nothing to do with anything, it is just quality that matters. You do not worry about newness, you just worry about whether something is good or bad, not whether it is new. Who cares if it is new?

**Student** Is it a problem for a professional designer who chooses not to use the computer?

**Rand** I do not think that is a problem. I think that is a problem with students who are learning design. I mean, all of a sudden, being confronted with these mechanical problems—that is just too much. You need to have a clear head and a clear path when you are learning design, you cannot be fiddling around with the computer.

Unfortunately, you have to, because that is the way it is, I mean, you will not get a job without it. That is one problem we did not have. It was not necessary for us to know how to run a Linotype machine or print our own stuff—that was all given to somebody else. You can still give it to somebody else, let somebody else do the computer work, but you will not get a job unless you do [the work], unfortunately.

You kids are young enough to absorb all that; I am just too old for all that stuff. My wife and I tried, and we have the best equipment, just not interested. As soon as I start, I get up, the hell with this [laughter], especially when I have somebody who can do it just like that. I do not guarantee I am not going to try to learn it, but so far I have succeeded in avoiding it.

Do not misunderstand. I think that the computer is a marvelous instrument. I think the computer has nothing to do with creative work. You are not going to be a creative genius just because you have a computer. In fact the chances are you will be just the opposite. You just will be a computer operator. But the speed and the efficiency are simply incomparable. A comp in the old days consisted of type and artwork and color and Photostats and color prints. Can you imagine how long that took, and how much it cost to do? You do it in half an hour today; it used to take two weeks, literally two weeks. There is something wrong in that, too, because it does not give you time to be contemplative. You do not have time to sit and think about it, and it keeps kicking you in your rear

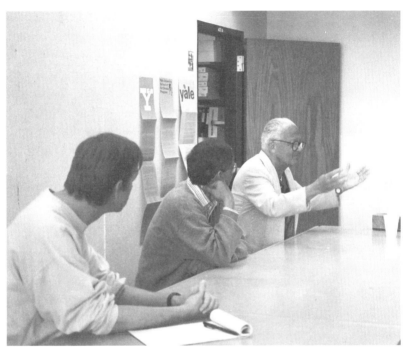

48

end as you go along. You know it keeps
kicking you. You cannot stop to think
about it because it is just too damn fast.
(Figure 48)

I must have rewritten my book
maybe seventy-five times because of
the computer. You know, let us fix that,
we fix it, and then we go back, and I
am doing another, and let us fix that—it
just goes back and forth. But if you did
not have that convenience, you would
work differently. I think this is the chief
difference, and one of the drawbacks of
the computer. It is just too damn fast.
And of course, that is also its virtue.
So what do you do? Don't ask me.

**Student** How do you deal with a client
who wants to make creative decisions
but does not have any knowledge of
design?

**Rand** That is a tough question because
that depends on how good you are,
number one, if you are right or wrong. I
mean, if you are wrong you have nothing
to stand on. So it is an impossible
question to answer. Or you have a client

who is very brilliant and is correct—that is very rare, but it is possible.

I am trying to think. It is virtually impossible but it happens, but you cannot be contentious with somebody. For example, Steve Jobs of NeXT is a very tough client. If he does not like something, you hand it to him and he says, "that stinks." There is no discussion. On the other hand, I was lucky enough, I suppose, when I did the logo for him. After he saw the presentation of it, he got up—we were all at his house, sitting on the floor, you know, Hollywood style, with the fireplace going, hot as hell outside. [laughter] He got up and looked at me and said, "Can I hug you." Now that is overcoming a conflict between the client and the designer.

We are not only designers, but we must deal with clients politically, socially, aesthetically—it is a very difficult problem. If you are convinced that you are right, well, that is a kind of an answer. There is only one answer for you, and that is either he takes it or he leaves it. That is the only answer, right! What else is there? I mean, if you're convinced that you are right, then you can only be independent, that is all you can be, which means you will probably lose your job.

On a freelance job that is no problem because if the guy doesn't like it, you say sorry. Assuming that he has already paid you. [laughter] Make sure whatever you do, get paid because he may not like what you do, and you may be doing a perfectly terrific job, and it is not fair. I think that you guys have squeezed enough blood out of my stony head (ha).

**Ater** Except one more question.

**Rand** One more question. There is always one more question.

**Ater** How do they go about working for you, working as a designer?

**Rand** Well, working for me is the worst because you will never get a chance to do any designing. I even tell my assistant—if I have one—I do not even want you to suggest anything. Just forget it. If you have great ideas, go home and do them, but do not show them to me. There is a reason for that. Many studios hire a bunch of designers, who get no credit for their work, but the principal gets the credit. I do not do that. In my studio you just do hack work, you know, lettering or computer or cut paper or whatever. There is no designing.

If I ever had a studio where you did design, you would be getting credit

for it. Because I think it is terrible not to. However, when you are looking for a job and you want to learn, I think you have to forego all of those luxuries. Because I did work for a designer, who I learned a great deal from, even though he took credit for my work. This is how it is, OK.

Thank you very much. No stones please.

[Applause]

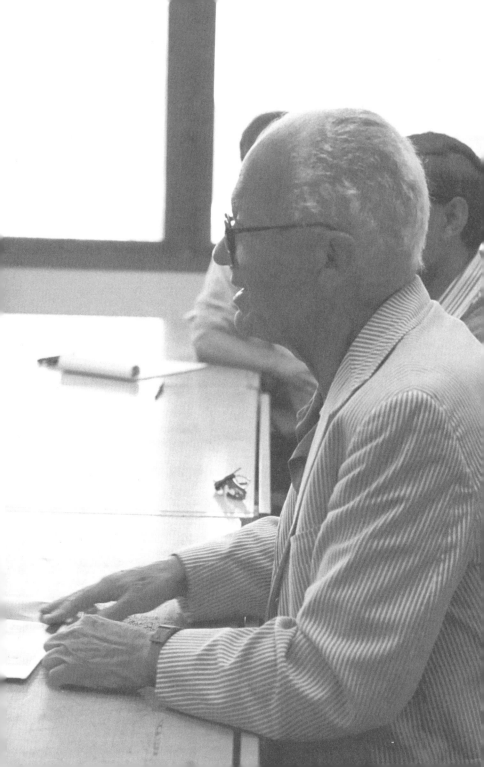

# Thoughts on Paul Rand

Philip Burton
Jessica Helfand
Steff Geissbuhler
Gordon Salchow
Armin Hofmann

"It was this, more than anything, I learned from him: how to really look—deeply, ruthlessly, penetratingly—and see."

Jessica Helfand

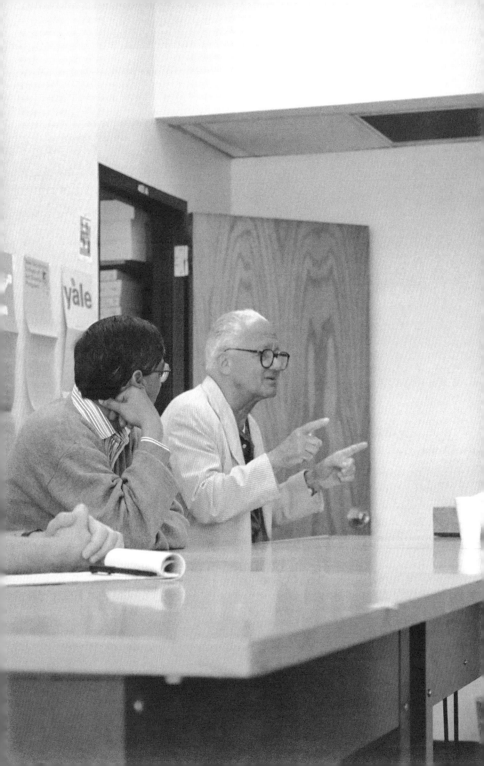

Once when asked to describe Paul Rand, I chose the word compassionate. My remark was met with incredulity. Could this be the same Paul Rand with a legendary reputation for orneriness? It was indeed.

Paul joined the faculty of the graduate graphic design program at Yale in 1955. He always said he didn't think he was a good teacher. But I doubt any of his former students could be found who don't remember a favorite Paul Rand story that continues to inspire them. They have to admit that they wouldn't be the same without having had him as a teacher.

Paul always taught on Friday mornings of the fall semester. The setup was the same every week. The conference room was prepared with a task lamp clipped to the table, a dozen freshly sharpened pencils and a stack of white bond paper ready. At the beginning of the semester, each student would come to present his or her portfolio. Paul would look it over carefully, putting his finger on the exact spot that needed attention and rattle off a list of ways to make improvements.

As the semester progressed, students advanced to a layout project for which they used text from the essay "Sur la plastique" (1925) by Amadée Ozenfant and Charles-Edouard Jeanneret (Le Corbusier) or Paul's own "Design and the Play Instinct" from *Education of Vision* (1965). Again the students would come to the conference room one at a time to show what they had done. Paul would thoughtfully reposition blocks of text that had been waxed down. As class time diminished, two, then three, and sometimes four students would crowd around the conference table to show the progress they were making. Paul would make adjustments to the layout that would improve the flow and serve as strategy for future projects. After class it was off to Mory's for chilled madrilene, dry turkey sandwich, and Jell-O.

In 1977 Armin Hofmann invited Paul to teach for a week as part of his summer workshop in the village of Brissago, Switzerland, just north of the Italian border. The idyllic setting of palm, banana, and bamboo trees surrounding a grand lake with snow-capped Alps as a backdrop didn't sway Paul. He was there to teach and was skeptical that anything could be accomplished in such a short time.

Classes were held in the local elementary school. Because the students had the summer off, we were able to use of the cafeteria as a classroom, two students sitting at each of eleven large tables. Paul would go from desk to desk carrying a collapsible garden stool with him so that he could sit and talk to each student about his or her work. Each tête-à-tête went on as long as was necessary to set the student on the right track and was laced with stories from Paul's vast career as they were appropriate to the issue at hand. When he worked with students, he poured his heart and soul into it.

Paul remained part of the core faculty of the Brissago program until it ended in 1996. It didn't take long for him to be convinced that this kind of concentrated and intense interaction with individual students was the best way to teach graphic design. He tried to transplant the one-project/one-week arrangement to the Yale program but because of the academic and extracurricular demands placed on the students, it never quite worked.

The conversations Michael Kroeger has captured of Paul (and sometimes Marion) with ASU colleagues and students may also have convinced you that Paul is someone who can best be described as compassionate.

Philip Burton

My graduate thesis at Yale was a long, dissertation-style treatise on the history of the square. Only one member of the graduate faculty actually took the time to read it—and that was Paul Rand.

"With what little time I've had to read Jessica's thesis, I have to conclude that the quality of the content deserves commendation," he wrote in my written review. "But it looks like you designed it in three days," he told me later. "It looks," he said, staring straight at me to make sure I got the message, "like a piece of crap."

Naturally, he was right: about the designing it in three days part, anyway. (Crap, I would later learn, is in the eye of the beholder.) But by then, I'd come to expect these sorts of no-nonsense pronouncements from my thesis advisor. "The development of new typefaces is a barometer of the stupidity of our profession!" "Graphic design is not surgery!" Rand was irascible, unforgiving, and impossible. Exalted standards of excellence were a point of pride with him. He loved form, hated market research, and fervently believed in the power of good design. He didn't suffer fools—or anyone for that matter—gladly.

Periodically I would visit him at his home in Weston, Connecticut, where we would sit at his kitchen table and talk. As we talked he would think of books he wanted me to read, and he would go and fetch them, often sending me home with duplicate copies of his favorites—many of them books on architecture, philosophy, art, even Judaica. I was the only Jewish girl in our class, and when he wasn't playing the tough guy in the studio at school, he treated my like a granddaughter, even down to administering just the right dose of guilt. "You disappeared like a phantom!" he wrote me in a letter when I'd failed to visit him for a month or two. Like both of my grandfathers, Rand was at once paternal and taciturn, deeply principled and given to great, gusty bouts of laughter at the slightest provocation. I'd bring him chocolates. He'd make me tea. We'd sit for hours and argue. I loved every minute of it.

I don't remember talking about design so much as just talking—about life, about ideas, about reading. "You will learn most things by looking," he would say, "but reading gives understanding. Reading will make you free." Once, he complained about the inadequacy of a text he wanted to assign the students,

faulting his then-current translation of Le Corbusier and Ozenfant's essay "Sur la plastique" ("On the Plastic in Art") from 1925. He knew I'd been raised in France and asked me to provide a better translation for him, which I did. And he knew enough French to know mine was, at least for his purposes, the better version.

Not because I was a better translator, but because by that time, under his tutelage, I'd become a more observant student of design. And it was this, more than anything, that I learned from him: how to really look—deeply, ruthlessly, penetratingly—and see.

Years later, after I was married, I happened to be in Philadelphia with my husband, Bill, when Rand was in town to give a lecture. Now frail and in his early eighties, we arranged to pick him up and deliver him back to his hotel at the end of the evening. As we helped him out of the taxi, he stopped, put his arm around me—we were the same exact height—and gave me a squeeze. Then he turned sternly to Bill. "You know, I'm not at all sure you're good enough for her," he barked. "But you'll do." I felt so relieved and grateful that he chose, in what would be our last conversation, to critique my husband—and not my thesis. I still miss him.

Jessica Helfand

## Paul, the Devil's Advocate

When the local advertising community questioned the teaching methodology of the faculty—made up of Ken Hiebert, Ave Pildas, Keith Godard, and I—at the Philadelphia College of Art, they threatened to withhold their financial support of the college and selected a group of designers to investigate the program. This was around 1969. The jury chosen consisted of Will Burtin, Paul Rand, and Armin Hofmann.

Rand led the questions and played the interrogator during the weeklong inquisition. We soon realized that the other jury members were not going to say much, and we couldn't get in touch with Hofmann who was supposed to defend us. Rand was very tough, accusing me, for example, of being a pop artist because I had my students paint graphics on found objects (shoes, toys, etc.) as an exercise in whether they could change or estrange the object with color and form. (Rand had a great disdain for Pop Art and never acknowledged it as being a part of art or design history.) He also thought that I did not have any business teaching at my age. I was twenty-seven. I was ready every night to pack my bags and return to Switzerland.

The commission left for New York that weekend to submit their report, which documented all the faculty members, the curriculum, methodology, and the department as a whole, to the college and the advertising community. We received an A+—they were completely supportive of everything we were doing. Paul Rand had played the Devil's Advocate convincingly and held our feet to the fire in order to test our beliefs. In a surprising turn of events, I started to consult for N. W. Ayer, one of the main accusers, shortly thereafter.

## Paul, the All Knowing

Many years later as a partner at Chermayeff & Geismar, I designed signage for IBM 590, the new and only IBM building in Manhattan, on Fifty-seventh Street and Madison Avenue (designed by the architect Edward Larrabee Barnes in 1983). A part of the project was an exterior identification sign. I based the design on Rand's IBM logo, and placed the number 590 in the striped IBM typeface to be cut into the granite on the other side of the entrance. As usual I surveyed the area closely and taped a to-size blueprint on the granite, where I thought it should go.

The next day I was informed that someone had moved the drawing. I went back and re-taped it where it had been the day before. Same thing next day. Even though the architect confirmed that Rand was not involved, I was suspicious. I called Paul, who simply said, "I was wondering how long it would take you before you called me." He agreed with my design; he just didn't want anybody to do anything with his logo without him giving his blessing. Years later, Paul asked Ivan, Tom, and me to come to Armonk and review all IBM graphics worldwide.

I liked and respected Paul Rand a lot. He had the attention and admiration of his clients. He was an Untouchable and was revered by IBM, Westinghouse, Cummins, for example, like a king. People were afraid of him. He never compromised; he never wavered. He showed one solution—take it or leave it. He was also the toughest critic of other designers.

Steff Geissbuhler

I first met Paul Rand thirty years into his pioneering initiatives when I was one of his most naive graduate students at Yale University in 1963. I grew to know him over the subsequent few decades, to comfortably use his first name, but his revered persona certainly prevented any such familiarity early on. He was, in and out of the classroom, reliably direct, honest, and insightful. His forceful intellect blended with a refreshing playfulness that fostered unbridled clarity and creativity in his own work. The brevity of his comments were poetically complex. Conversations often became penetrating and elevated one's perspective.

Shortly after my 1968 move to the University of Cincinnati to establish a new graphic design program, I invited Paul to be a visiting critic. He agreed, and we had some contentiously enlightening sessions with my students and the faculty. I recall, in particular, his visit to our apartment. I was feeling some swagger as an upstart department head and my wife, Kathy, and I had recently invested in some new quasi-Danish teak furniture. Paul sat down and, instead of graciously accepting our hospitality, he pointedly critiqued the crummy proportions and subtleties of our stuff. That was, in fact, the most gracious thing that he could have done. It was an important postgraduate lesson concerning design that enhanced my understanding, future standards, and respect for Paul. I was nudged to believe that excellence, as a way of life, was a prerequisite to being a superior designer or educator. How we live reflects our true understanding and nourishes us concerning what we do.

My last encounter with Paul happened within the year before he died. He and his wife Marion were in Cincinnati to lecture for the Art Directors' Club. Kathy and I spent a wonderful afternoon with them. We went for a ride and had lunch; Paul and Marion visited our home. He complimented our house and furnishings; we felt vindicated because I knew that he was incapable of shallow praise. I used the opportunity, that day, to tell him that I was convinced that his artistry, influence, and consequent place in history was absolutely parallel to that of our greatest architects, authors, artists, and musicians. He turned and shook my hand but, for once, did not seem able to say anything.

I was privileged to have been his student and I am proud to have known him. He was, without a doubt, a rare intellectual and creative genius whose spectacular contributions to our human legacy add inspiration and quality to everyone's lives.

Gordon Salchow

Paul Rand taught for four decades at the Yale University School of Art as well as at the summer program in Brissago, Switzerland. He passed his knowledge on spontaneously, dealing with current problems in visual communication by working closely with the students. Paul always illustrated his knowledge through practical examples, offering others an insight into his own approach.

I first met Paul at the studio of Lester Beall in 1956. What followed was thirty years of continuing encounters in connection to our teaching responsibilities at Yale in New Haven. This provided us the opportunity to discuss pedagogical questions, among them, the effect new technologies had on teaching.

A strong professional and educational connection between us resulted from the summer program in Brissago as well, where Paul taught one week for more than twenty years. Rand's Visual Semantic project was very intense and demanding and was considered by the students to be a high point of the five-week seminar.

The collaboration that connected us both as human beings and as professionals remains one of the most treasured experiences for me as a teacher and as a designer.

Armin Hofmann

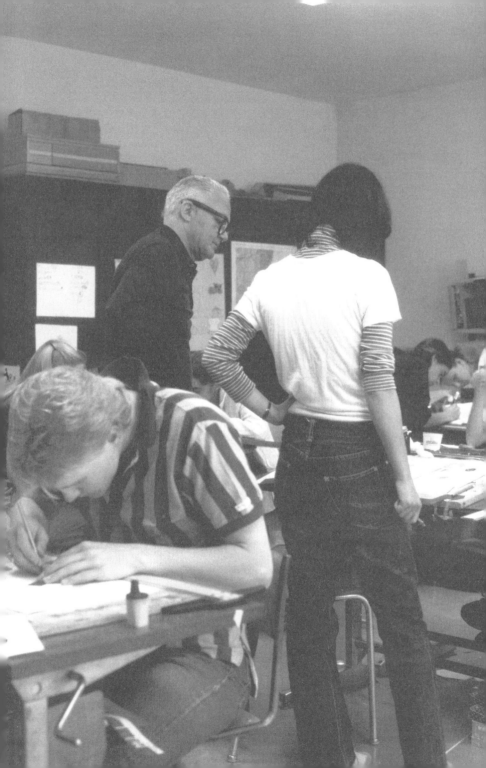

"Students should know about these things. It is a good book to read."

401 A

Y

Yale University
School of
Art Graduate
Programs

yale

## Typography

The Beinecke Rare Book and Manuscript Library. *The First Twenty Years.* New Haven, CT: Yale University Library, 1983.

Carson, David. "Influences: The Complete Guide to Uncovering Your Next Original Idea." *HOW Magazine,* March/April 1992.

Carter, Rob. *American Typography Today.* New York: Van Nostrand Reinhold Company, 1989.

Carter, Rob, Ben Day, and Philip Meggs. *Typographic Design: Form and Communication.* New York: Van Nostrand Reinhold Company, 1985.

Craig, James. *Designing with Type: A Basic Course in Typography.* New York: Watson-Guptill Publications, 1971.

Denman, Frank. *The Shaping of Our Alphabet.* New York: Alfred A. Knopf Publisher, 1955.

Felici, James. *The Complete Manual of Typography.* Berkeley, CA: Peachpit Press, 2003.

Frutiger, Adrian. *Type Sign Symbol.* Zürich, Switzerland: ABC Verlag, 1980.

Gerstner, Karl. *Compendium for Literates: A System of Writing.* Cambridge, MA: MIT Press, 1974.

Gill, Eric. *An Essay on Typography.* Boston, MA: David R. Godine, Publisher, 1988. First published 1931 by Sheed & Ward.

Goudy, Frederic W. *The Alphabet and Elements of Lettering.* New York: Dover Publications, Inc., 1963. First published 1918 by Frederic W. Goudy.

Hurlburt, Allen. *Layout: The Design of the Printed Page.* New York: Watson-Guptill Publications, 1977.

Kane, John. *A Type Primer.* New York: Prentice Hall, Inc., 2003.

Kelly, Rob Roy. *American Wood Type: 1828–1900.* New York: Da Capo Press, 1977.

Kunz, Willi. *Typography: Macro- and Microaesthetics.* Basel, Switzerland: Verlag Niggli AG, 1998.

Lawson, Alexander. *Printing Types: An Introduction.* Boston: Beacon Press, 1971.

Lewis, John. *Typography: Basic Principles.* New York: Reinhold Publishing Corporation, 1964.

McLean, Ruari. *Jan Tschichold: Typographer*. London: Lund Humphries, 1975.

———. *The Thames and Hudson Manual of Typography*. London: Thames and Hudson Ltd., 1980.

Meyer, Hs. ed. *The Development of Writing*. Zürich, Switzerland: Graphis Press Zürich, 1968.

Morison, Stanley. *A Tally of Types*. Cambridge: Cambridge University Press, 1973.

Ogg, Oscar. *The 26 Letters*. New York: The Thomas Y. Crowell Company, 1948.

Ruder, Emil. *Typography*. New York: Hastings House Publishers, Inc., 1981.

Rüegg, Ruedi. *Basic Typography: Design with Letters*. New York: Van Nostrand Reinhold Company, 1989.

Smith, Dan. *Graphic Arts ABC*. Chicago: A. Kroch & Son, Publishers, 1945.

Spencer, Herbert. *Pioneers of Modern Typography*. Cambridge, MA: MIT Press, 1983. First published 1969 by Lund Humphries Publishers Ltd.

Tufte, Edward R. *Envisioning Information*. Cheshire, CT: Graphics Press, 1990.

———. *The Visual Display of Quantitative Information*. Cheshire, CT: Graphics Press, 1983.

Weingart, Wolfgang. *Projekte/Projects Volume 1*. Basel, Switzerland: Verlag Arthur Niggli AG, 1979.

———. *Schreibkunst. Schulkunst und Volkskunst in der deutschsprachigen, Schweiz 1548 bis 1980*. Zürich: Kunstgewerbemuseum der Stadt Zürich, Museum für Gestaltung, 1981.

———. *Typography: My Way to Typography*. Basel, Switzerland: Lars Müller Publishers, 2000.

**Graphic Design**

Ades, Dawn. *The 20th-Century Poster: Design of the Avant-Garde*. New York: Abbeville Press Publishers, 1984.

Albers, Joseph. *Despite Straight Lines*. Cambridge, MA: MIT Press, 1977.

Arx, Peter von. *Film Design*. New York: Van Nostrand Reinhold Company, 1983.

Bernstein, Roslyn, and Virginia Smith, eds. *Artograph #6 / Paul Rand*. New York: Baruch College / CUNY, 1987.

Biesele, Igildo G. *Experiment Design.* Zürich, Switzerland: ABC Verlag, 1986.

———. *Graphic Design Education.* Zürich, Switzerland: ABC Verlag, 1981.

Brockman, Cohen, Arthur A. *Herbert Bayer: The Complete Work.* Cambridge, MA: MIT Press, 1984.

Friedman, Dan. *Dan Friedman: Radical Modernism.* New Haven and London: Yale University Press, 1994.

Grear, Malcolm. *Inside/Outside: From the Basics to the Practice of Design.* New York: Van Nostrand Reinhold Company, 1993.

Greiman, April. *Hybrid Imagery: The Fusion of Technology and Graphic Design.* New York: Watson-Guptill Publications, 1990.

Haworth-Booth, Mark. *E. McKnight Kauffer: A Designer and His Public.* London: Balding and Mansell, 1979.

Hauert, Kurt. *Umsetzungen/Translations.* Basel, Switzerland: Werner Moser/Schule für Gestaltung, 1989.

Heller, Steven, and Louise Fili. *Dutch Moderne Graphic Design from De Stijl to Deco.* San Francisco: Chronicle Books, 1994.

Heller, Steven. *Paul Rand.* London: Phaidon Press Limited, 1999.

Hiebert, Kenneth J. *Graphic Design Processes: Universal to Unique.* New York: Van Nostrand Reinhold Company, 1992.

Hofmann, Armin. *Armin Hofmann: His Work, Quest and Philosophy.* Basel, Switzerland: Birkhäuser Verlag, 1989.

———. *Graphic Design Manual.* New York: Van Nostrand Reinhold Company, 1965.

Itten, Johannes. *The Art of Color: The Subjective Experience and Objective Rationale of Color.* New York: Van Nostrand Reinhold Company, 1973. First published 1961 by Otto Maier Verlag.

———. *Design and Form.* New York: John Wiley & Sons, Inc., 1975. First published 1963 by Ravensburger Buchverlag Otto Maier GmbH.

Johnson, J. Stewart. *The Modern American Poster.* Kyoto, Japan: The National Museum of Modern Art, 1983.

Kepes, Gyorgy. *Language of Vision.* 1944. Reprint, Chicago: Paul Theobald and Co., 1969.

Kuwayama, Yasaburo. *Trademarks & Symbols of the World.* Vol. 2, *Design Elements.* Rockport, MA: Rockport Publishers, 1988.

——. *Trademarks & Symbols of the World.* Vol. 3, *Pictogram & Sign Design.* Rockport, MA: Rockport Publishers, 1989.

——. *Trademarks & Symbols of the World 2.* Tokyo: Kashiwashobo Publishing Co., Ltd. 1989.

Maier, Manfred. *Basic Principles of Design.* 4 vols. New York: Van Nostrand Reinhold Company, 1977.

Müller-Brockmann. *Grid Systems in Graphic Design.* Zurich: A. Niggli, 1961.

Nelson, George. *George Nelson on Design.* New York: Whitney Library of Design, 1979.

Neumann, Eckhard. *Functional Graphic Design in the 20s.* New York: Reinhold Publishing Corporation, 1967.

Rand, Ann, and Paul Rand. *I Know A Lot of Things.* New York: Harcourt, Brace, Jovanovich, Inc., 1956.

——. *Listen! Listen!* New York: Harcourt, Brace & World, Inc., 1970.

——. *Little 1.* New York: Harcourt, Brace & World, Inc., 1962.

——. *Sparkle and Spin: A Book About Words.* San Francisco: First Chronicle Book, 1957.

Rand, Paul. *Design Form and Chaos.* New Haven, CT: Yale University Press, 1993.

——. *From Lascaux to Brooklyn.* New Haven, CT: Yale University Press, 1996.

——. *Paul Rand: A Designer's Art.* New Haven, CT: Yale University Press, 1985.

——. *Thoughts on Design.* New York: Wittenborn, Schultz, Inc. Publishers, 1947.

Sesoko, Tsune. *The I-Ro-Ha of Japan.* Tokyo: Cosmo Public Relations Corp., 1979.

Skolos, Nancy, and Thomas Wedell. *Ferrington Guitars.* New York: HarperCollins Publishers and Callaway Editions, Inc., 1992.

Thompson, Bradbury. *The Art of Graphic Design.* New Haven and London: Yale University Press, 1988.

Wingler, Hans M. *The Bauhaus.* Cambridge, MA: MIT Press, 1979.

Zapf, Hermann. *Manuale Typographicum*. Cambridge and London: MIT Press, 1970.

Zender, Mike. *Designer's Guide to the Internet*. Indianapolis, IN: Hayden Books, 1995.

## Graphic Design History

Friedman, Mildred. *Graphic Design in America: A Visual Language History*. Minneapolis, MN: Walker Arts Center, 1989.

Margolin, Victor, ed. *Design Discourse: History, Theory, Criticism*. Chicago: University of Chicago Press, 1989.

Meggs, Philip B. *A History of Graphic Design*. New York: John Wiley & Sons, Inc., 1983.

Müller-Brockmann, Joseph. *A History of Visual Communication*. Basel, Switzerland: Verlag Arthur Niggli Ltd., 1971.

Müller-Brockmann, Joseph, and Shizuko Müller-Brockmann. *History of the Poster*. Zürich, Switzerland: ABC Verlag, 1971.

## Graphic Design Production

Bruno, Michael H. *Pocket Pal*. 1934. Reprint, New York: International Paper Company, 1973.

Craig, James. *Production for the Graphic Designer*. New York: Watson-Guptill Publications, 1974.

Gates, David. *Graphic Design Studio Procedures*. Monsey, NY: Lloyd-Simone Publishing Company, 1982.

Gregory, R. L. *Eye and Brain: The Psychology of Seeing*. New York: McGraw-Hill Book Company, 1981. First published 1966 by World University Library.

Hurlburt, Allen. *The Grid*. New York: Van Nostrand Reinhold Company, 1978.

———. *Publication Design*. 1971. Reprint, New York: Van Nostrand Reinhold Company, 1976.

Romano, Frank J. *Pocket Guide to Digital Prepress*. Albany, NY: Delmar Publishers, 1996.

Strunk, Jr., William, and E. B. White. *The Elements of Style*. 3rd ed. New York: Macmillan Publishing Co., Inc., 1979.

University of Chicago Press. *The Chicago Manual of Style*. 13th ed. Chicago: The University of Chicago Press, 1982.

**Fine Arts / History**

Ball, Richard, and Peter Campbell. *Master Pieces: Making Furniture from Paintings.* New York: Hearst Books, 1983.

Barr, Jr., Alfred H. *Picasso: Fifty Years of His Art.* 1946. Reprint, New York: The Museum of Modern Art, 1974.

Chaet, Bernard. *An Artist's Notebook: Techniques and Materials.* New York: Holt, Rinehart and Winston, 1979.

Dewey, John. *Art as Experience.* New York: Perigee Books, 1980. First published 1934 by John Dewey, Barnes Foundation, Harvard University.

Diehl, Gaston. *Miró.* New York: Crown Publishers, Inc., 1979.

Doelman, Cornelius. *Wassily Kandinsky.* New York: Barnes & Noble, Inc., 1964.

Geelhaar, Christian. *Paul Klee Life and Work.* Woodbury, NY: Barron's Educational Series, Inc., 1982.

Goldwater, Robert. *Paul Gauguin.* New York: Harry N. Abrams, Inc., 1983.

Jacobus, John. *Henri Matisse.* New York: Harry N. Abrams, Inc., 1983.

Klee, Paul. *Pedagogical Sketchbook.* Translated by Sibyl Moholy-Nagy. New York: F. A. Praeger, 1953.

Kotik, Charlotta. *Fernand Leger.* New York: Abbeville Press, 1982.

Lenssen, Heidi. *Art and Anatomy.* New York: Barnes & Noble, 1963. First published by J. J. Augustin, Inc., 1946.

Myers, Bernard S. *Modern Art in the Making.* New York: McGraw-Hill Book Company, 1950.

Newhall, Beaumont. *The History of Photography.* New York: The Museum of Modern Art, 1964.

Ozenfant, Amadée. *Foundations of Modern Art.* New York: Dover Publications, Inc., 1952. First published by Esprit Nouveau, 1920.

Richardson, John. *A Life of Picasso.* Vol. 1, *The Early Years, 1881–1906.* New York: Random House, 1991.

———. *A Life of Picasso.* Vol. 2, *1907–1917: The Painter of Modern Life.* New York: Random House, 1996.

Rubin, William. *Pablo Picasso: A Retrospective.* New York: The Museum of Modern Art, 1980.

Schmalenbach, Werner. *Kurt Schwitters.* New York: Harry N. Abrams, Inc., Publishers, 1980. First published 1934 by Verlag M. DuMont Schauberg.

Taillandier, Yvon. *P. Cézanne.* New York: Crown Publishers, Inc., 1979.

Information Theory / Philosophy / Critical Writings

Barthes, Roland. *Criticism & Truth.* Minneapolis: University of Minnesota Press, 1987.

Beardsley, Monroe C. *Aesthetics: Problems in the Philosophy of Criticism.* New York: Harcourt, Brace and World, 1958.

Bierut, Michael, William Drenttel, Steven Heller, and D. K. Holland. *Looking Closer: Critical Writings on Graphic Design.* New York: Allsworth Press, 1994.

Campbell, Jeremy. *Grammatical Man.* New York: Simon & Schuster, Inc., 1982.

Chomsky, Noam. *Aspects of the Theory of Syntax.* Cambridge, MA: MIT Press, 1965.

Dondis, Donis A. *A Primer of Visual Literacy.* Cambridge and London: MIT Press, 1973.

Gerstner, Karl. *Compendium for Literates.* Cambridge, MA: MIT Press, 1974. First published 1972 by Arthur Niggli, Teufen.

Hegel, Georg Wilhelm Friedrich. *Aesthetics: Lectures on Fine Arts.* Translated by T. M. Knox. Oxford: Clarendon Press, 1975.

———. *The Philosophy of History.* New York: Dover Publications, Inc., 1956.

Kepes, Gyorgy. *Education of Vision.* New York: G. Braziller, 1965.

Nadin, Mihai, ed. "The Semiotics of the Visual: On Defining the Field." Special issue, *Semiotica* 52, no. 3/4 (1984).

Porter, Kent. *COMPUTERS Made Really SIMPLE.* New York: Thomas Y. Crowell, Publishers, 1976.

de Saint-Exupéry, Antoine. *Airman's Odyssey.* Orlando, FL: Harcourt Brace & Company, 1956.

Van Doren, Charles Lincoln. *A History of Knowledge: Past, Present, and Future.* Secaucus, NJ: Carol Publishing Group, 1991.

Wallas, Graham. *The Art of Thought.* New York: Harcourt, Brace and Company, 1926.

Whitehead, Alfred North. *Science and the Modern World.* New York: Macmillan, 1926.

## Architecture

Blake, Peter. *Form Follows Fiasco: Why Modern Architecture Hasn't Worked.* Boston: Little, Brown and Company, 1977.

Davidson, Cynthia C. *Eleven Authors in Search of a Building.* New York: Monacelli Press, Inc., 1996.

Scully, Jr., Vincent. *Modern Architecture.* New York: George Braziller, 1965.

Venturi, Robert. *Complexity and Contradiction in Architecture.* Garden City, NY: Doubleday & Company, 1966.

White, Norval. *The Architecture Book.* New York: Alfred A. Knopf, 1976.